IMAGES
of America

BASALT

The names of the Ute Indians shown here are unknown, but William H. Harris (second from left) and Joseph Kelly can be identified. Harris and Kelly befriended the Indians and invited them to revisit their ancestral home in Basalt for the 1910 Fair, where they posed together in front of a plain white backdrop. Kelly holds a cigar in hand, while the Ute on the far left has one pursed in his lips.

ON THE COVER: The history of Basalt is inextricably tied to the Colorado Midland Railway and Denver & Rio Grande Western Railroad, which once called it home. A group of community members stand next to the damaged Schenectady Locomotive Works engine, destroyed in a runaway train accident up the Frying Pan. This view, looking north, with the damaged engine facing east, shows the current Homestead Drive in the background. A new engine stands ready behind. Today, one can stand at this same location and view some of the identical residences up the hill from the downtown core.

IMAGES
of America

BASALT

Bennett A. Bramson

ARCADIA
PUBLISHING

Published by Arcadia Publishing
Charleston, South Carolina

Printed in the United States of America

Library of Congress Control Number: 2013945091

For all general information, please contact Arcadia Publishing:
Telephone 843-853-2070
Fax 843-853-0044
E-mail sales@arcadiapublishing.com
For customer service and orders:
Toll-Free 1-888-313-2665

Visit us on the Internet at www.arcadiapublishing.com

This book is lovingly dedicated to the memory of my parents, Selma "Sally" Bramson Middleton and Jess Allen Bramson.

CONTENTS

FOREWORD

Basalt, Colorado, is a mountain community in southwestern Eagle County, located at the confluence of two Gold Medal trout streams—the Frying Pan and the Roaring Fork rivers. The Colorado Midland Railway, the life-blood of Basalt, was built to carry coal and silver ore between Leadville and Aspen. The railway established the Town of Frying Pan Village in 1887, which later became known as Aspen Junction.

Incorporated as Basalt in 1901, the mountain town filled with immigrants from Switzerland and Northern Italy for jobs with the railway, mines, and coal smelters. Signs of the great railroad era still remain today in a town now reborn as a vibrant community, catering to both tourists and locals. Basalt residents place high value not only on its small town characteristics, but also on the historical preservation of the lovely buildings along the downtown core while creating savvy, new upscale businesses.

Basalt truly embraces the spirit of the Old West, as well as the infinite possibilities ahead. Basalt meets the challenges of growth and community through tolerance, compassion, intelligence, and fun.

We applaud and congratulate Bennett Bramson for writing the definitive book chronicling Basalt's amazing multistoried history.

—Mayor Jacque Whitsitt

ACKNOWLEDGMENTS

Inspirations for authoring this book have come from so many sources. First and foremost is my beloved brother, Seth H. Bramson, an author of more than 21 books on the history of South Florida and its communities and the railroads which served it; my sister-in-law, Myrna Bramson, a true friend and supporter; my inspirational daughter, Dara Bramson, herself a 3-time published author, freelance writer, philanthropist, and amazing human being, who continues to make positive change in the world, and my best friend, biggest supporter, and strength in life—my wife, Jessica, "Jess."

So many people were instrumental and supportive in the development of this book, from sharing time, knowledge, memories, and photographs, to family and personal memorabilia. I want to gratefully acknowledge the support and contributions provided by the town of Basalt, particularly Sally Ferren and Pam Schilling; Cali Gonzales; Boris Milvich; Megan and the team at Basalt Print and Copy for donating their time and services to scan the photographs and create DVDs; the Basalt Chamber of Commerce; Brain McNellis and Denise Tomaskovic; Beth White and the Mount Sopris Historical Society; Dolores Stutsman; the Gerbaz family; Aspen Historical Society; Stacey and Adele Craft (my eighth grade research assistant); Glenwood Springs Railroad Museum; Karl Spence; David Martinek; Jim Corbitt; Sarah Glassier; Richard Zinn; Lee and Donna Willits; Tom Van Wormer; Larry Schrenk; Desmond Harris; Wayne and Marilyn Hyrup; Adele Crawford; Lois Arbaney; Carolyn Cerise-Barabe; Stacia Bannerman and the team at Arcadia Publishing, for their patience and understanding; and many others who have lent their support and assistance in the creation of this book with suggestions, recommendations, and referrals.

Unless otherwise noted, the images in this volume appear courtesy of Janice and Leroy Duroux and the Basalt Regional Heritage Society. If there is anyone who I have inadvertently forgotten or omitted, please accept my deepest apologies and heartfelt thanks.

INTRODUCTION

There have been other books written on the history of Basalt. Some focus on the details, the people, or the places; some take a more finite view of the aspects that created Basalt, such as the railroads, the ranching, the farming, or the mining.

But, the essential difference, and purpose, of this book was to capture in photographs (most of which have never been published before) the true essence of a small, but unique town, now comprised of several parts, and provide an updated view of the Basalt that was, the Basalt that is, and the Basalt that will be.

Many of these photographs are from the personal files and treasure troves of the families who built the community, their names forever carved into the legend of the town. These now serve as the names of some of the areas of town, in their honor. A visit to Basalt and environs beckons the visitor to ask, "Why is this area called Willits? Arbaney Park? Emma? What was the Sloss Building or Smith Brothers buildings? What is Fiou Park and Fiou Lane? Cerise Ranch? Duroux Lane? Harris Street?"

This town of 3,857 permanent residents (according to the 2010 census) has often grappled with modernization and the challenges of balancing sound, sensible development, while working to maintain and protect the legacy of its founders, it history, and its quality of life.

Unlike some of its larger neighboring communities, Basalt was, and still is, the heart and the epicenter of a thriving valley, the Roaring Fork.

To the east, Aspen became renowned first for its silver mines, later the development of its skiing and resort business, and today as a mecca of summer culture and winter sports.

At the western ends of the Valley, Carbondale began to develop as a gateway to Mount Sopris, Marble, Redstone, the Crystal River Valley, and carved out its own niche. Today it is recognized by National Geographic's *Explorer Magazine* as one of the top 10 places to live in the United States. Glenwood Springs, another historic city, which hosted Teddy Roosevelt at its historic Hotel Colorado, boasts the famous hot springs, caverns, and the site of the tomb of the infamous Doc Holliday. It has become recognized by Rand McNally as the "Most Fun City in the U.S."

Yet, the Roaring Fork Valley is less of a series of disjointed towns and communities, and more akin to a 47 mile-long Main Street USA, connecting the municipalities on each end with an idyllic town and its environs in the center, offering the best of all worlds, without the hustle or bustle, without the crowded streets or traffic, and without the other related issues of some of its larger neighbors. Welcome to Basalt, Colorado!

Today's Basalt has survived through prosperity and decline, eras rife with mining, ranching, farming, and the advent and disappearance of the railroads. Few vestiges of the by-gone heydays of passenger rail travel and freight trains remain. Most of the rail beds and tracks have been replaced with a system of biking and hiking trails throughout the valley. Some of the rails are still visible in areas near Emma, providing a reminder of the days when trains rumbled along these routes several times a day.

The whole of Basalt is truly the sum of its integral parts. A trip to Basalt is not complete without visiting its historical downtown, the old area of Emma, El Jebel, the vibrancy of the new Willits, Arbaney Park, up the Frying Pan where the railroad once ran to the magnificent Ruedi Reservoir, South Side, Elk Run, or a trek along its famous rivers.

Basalt has always been a gorgeous location filled with natural beauty, wonderful amenities, easy access to important resources and infrastructures, and a focal point for many of the Valley's recreational, educational, and cultural pursuits. The town's location at the confluence of two Gold Medal fishing rivers (the only city in the United States with such a distinction) has now earned its rightful place as a legend in the fly-fishing world, adding to its resume.

So, dear reader, join us on this journey, as we embrace the glorious past, and embark on a bright future for Basalt, Colorado, which has truly become "The Confluence of Rivers, Recreation, and Culture."

One

FROM UTES TO RAILROADS

Well before the creation of what was to become Frying Pan Settlement/Junction or the area of Aspen Junction, the portion of the Roaring Fork Valley now known as Basalt, Colorado, was primarily the providence of the Ute Indians.

The tribe was spread across portions of the west through Colorado, Utah, Wyoming, and the Roaring Fork Valley, which provided ample stocks of deer, elk, bear, beaver, native fowl and vegetation, good growing soil, moderate spring, summer, and fall seasons, and navigable passes. Although fishing for the plentiful stocks of trout with handmade spears, bows and arrows, and crude hand cast lines must have been an incredible challenge, the Utes survived throughout the western territory.

As settlers moved westward in search of their fortunes, such as gold and silver, the Utes were forced to leave their lands and move on to the reservations, eventually becoming a decimated population.

The Ute Black Hawk War (1865–1868) erupted because of the havoc that settlers were inflicting on the lifestyle and ecosystems of the Native American, upon which the populations depended. After a protracted struggle that brought exhaustion to both sides, a peace treaty was signed in 1868, at which time the Ute Reservation was created by an act of Congress. While history will say the land was purchased for the new settlers following the Indian Wars of the 1860s, in reality, the Utes, like other native American tribes, were forced to accede to the growing demands of the pioneers and a government desirous of expanding its borders and reach. This is not meant to be taken as a political statement; rather, this was simply the reality of the times.

The uneasy treaty, which sealed the Ute's fate, led the way to mass immigration of new residents from east of the Mississippi River looking to make their fortunes in an area rife with minerals, mining deposits, abundant forests and plentiful water, and extensive wildlife. What more could a settler ask for?

In what is the heart of today's historic downtown Basalt, there was once a Ute village, later replaced by the train yards and depots of the Denver & Rio Grande Western Railroad and Colorado Midland Railway. These served as the hub of the Valley's mining, logging, farming, and rail passenger traffic to, and from Aspen, Glenwood Springs, and eventually points west.

Today, the area's only freight and passenger rail service is through Glenwood Springs, and one can ride the California Zephyr from Chicago to California through beautiful Glenwood Canyon and Glenwood Springs, and out to the West Coast. It is a magnificent journey which enables travelers to capture a piece of the feeling and essence of the area's history and romance.

The early Basaltines were miners, ranchers, and farmers. The primary farming crops were potatoes and strawberries, and the area was one of the largest producers of spuds outside of Idaho. While cattle and horse ranching are still prevalent in the valley, the potato industry and other agricultural endeavors faded, like the mining industry. Today, with opening of the Woody Creek Distillery in the Mid-Valley Design/Business Center, potato farming, for use in making vodka, has returned. This photograph was taken in the area of a current residential area called Blue Lake, just west of El Jebel and Willits.

The Willits family, whose descendants still live in an area of Basalt now named in their honor, gather for this family photograph in 1889. It was taken by Drenkel Photographers of Monarch Street in Aspen. Seated from left to right are (first row) patriarch Lee R., Pearl, and Cornelia; (second row) Irene and Marcia. Little Bramblet sits below Pearl.

Here, Flavin Cerise (on horse in rear) and some workers gather near the railroad tracks, in an area of the mid-valley, thought to be near Emma. From their tools and equipment, it appears they may have been engaged in track or bedding repair. The Cerise family members are still active in the community today.

This c. 1896 formal family portrait shows, from left to right, Albert, Ralph, and Raymond Harris. Dressed in double breasted suits, vests, spats, knickers, high collars, and bow ties, the boys stand in front of a photographer's backdrop, next to a Victorian-style lounger.

On what is thought to be the site of today's historical downtown, surveyors' tents are pitched near some ranch fences, with Black Mountain, later Basalt Mountain, in the background. Even for a small, often "best kept secret of a town," it is truly inspiring to view the pristine environment and landscape from which a wonderful community was carved.

Pioneering spirit and camping (which was a necessity, not simply a pleasure as it is today) were the hallmarks of those who settled and developed the area. Here, surveyors and settlers huddle around a raging campfire as portions of their tents are clearly visible on the left and right. Four essentials were required, boots, hats, ties, and determination.

In the mid-1800s, before it became the town of Basalt, its environs were rugged, unsettled, and yet truly pristine. Here, a group of farmers, miners, and even settlers, stops in an open meadow with some hills and mountain peaks in the background. Today, it is difficult to determine the exact location of this photograph.

Farming and ranching were arduous family affairs and required long hours to achieve any measure of success. In this photograph, a group of farmers and ranchers in the Emma area are harvesting hay in preparation for winter. Note the steam tractor to the right. Work began before sunrise and continued until late evening, with short breaks for meals where families, farm, and ranch hands all dined together. The days were long, the work was hard, and the pay was small.

This view, probably taken on the same property as the previous image, shows a horse ranch and a family, who were all part of the daily business. The men and horses are to the left, the women and children to the right, and a dog or two can also be seen scrounging around. It was this sense of pioneering spirit which led to the growth of a vibrant community.

Another view of the difficult and tedious job of potato farming is seen here. The harvest required manpower and horsepower. The gentlemen on the left are either overdressed for the job or supervising.

The land was barren and the work was challenging. Here, a surveyor's team is lined up with their equipment, their large tent visible in the background.

The job of surveyors in the area was often fraught with incredible challenges. In this photograph, the team manages to deal with forests and woods, high and steep terrain, raging rapids, rocks, boulders, inhospitable weather, and wildlife. The pioneering spirit was truly alive in Basalt and the Roaring Fork Valley.

While many of the original immigrants came from Italy and Switzerland, Basalt later became a melting pot of families from Germany, Russia, Poland, and other European countries. Here, Flavin Cerise (third from left) stands with some friends. The man second from left is holding a cup in his left hand and the other man's suspender strap in his right.

Seen in several photographs in this book, Lee R. Willits changed his look from a full beard, to a moustache connected to sideburns in the family photograph on page 11, to a more dapper moustache, still with flair, in this 1900 version. The area of Willits today, named for his family, has become a thriving, vibrant area of mixed-use residential and commercial developments.

This is the real west. A wagon train traverses the Frying Pan (Road and River). At the time, this was a modern mode of transportation, though slow, tedious, dirty, and often dangerous. A broken axle or wagon wheel and threats from bears, mountain lions, coyotes, and other wildlife made this voyage treacherous, to say the least. Yet, everything in the Valley tended to be cyclical; these roads were replaced by the rail lines of the Colorado Midland, and then after the departure of the rails, a return to the roads of the same name is what exists today, though in much improved form.

The deed for the property of Gustavius Grace, totaling 155.60 acres, signed by the secretary of then president of the United States Benjamin Harrison in 1897, is shown here. The Grace property has been subdivided, and near the site of the old Emma schoolhouse a new Grace church was recently built, after much contentious and litigious debate with Pitkin County.

This 1896 photograph of Lee R. Willits, the earliest of his images in the book, was taken by H.R. Gillespie for the *Magazine of Western History* (visible just below Willits). The image shows this handsome gentleman, a Basalt area settler and family man, and the personification of late 19th and early 20th-century photograph styles.

In this photograph from August 1875, Auguste Letey and wife, Cesarine Arbaney, pose for the photographer, Kirwan. Letey owned El Jebel Ranch before the Favre's, and his memorial book from 1944 is shown elsewhere in this book. The couple had no children.

This is a wedding photograph of Vinance and Palmira Favre. The Favres purchased the El Jebel Ranch from Auguste Letey.

This incredible view to the southwest, taken around 1900, features a snowcapped Mount Sopris in the background. Likely, this is a spring or early fall view taken from above High Street or Second Street. Notice that there is no snow visible on the ground, on the valley floor, or in the town. Close inspection reveals trains on both the Colorado Midland and Denver & Rio Grande Western tracks. The D&RGW train (in the background) is ready to take its freight to Aspen, while the CMRW train, closer to the camera, prepares for its voyage up the Frying Pan. The view clearly shows the rear of the Kelly Block Building, with the train depot (with the gabled roof and lattice on side) just across to the left, and on the far left is the Frying Pan Inn, with some smoke arising from one of its fireplace chimneys.

These two strapping gentlemen are Vinance and Amie Favre. This is from a postcard, which was a popular way to preserve photographs.

Amie and Elaine Favre are seen here. Like many of the other pioneering families in the early part of the 20th century, the Favres settled in the Basalt area environs and owned the El Jebel Ranch.

Euphosine and Frank Favre were among the original families who settled in the Basalt area.

Various members of the Basalt community from the late 1800s, before the founding of the town, are seen here. Upon inspection, some longtime members of the community have indicated that they believe they see a cousin, uncle, or family friend, but most of the names are lost to history.

Elvira and Humber Perrachon strike a stern pose for this photograph. It was traditional in the late 1800s and early 1900s for the gentleman to be seated and the woman to be standing at his side. The protocol for today's photographs is likely to be reversed.

Two

A Farmer's, Rancher's, or Miner's Life for Me

Into the late 19th century, mining became the largest industry in the Valley. Areas to the east of Basalt saw enormous development as the silver frenzy engulfed the country.

Many of the new residents, also found the area, climate, and resources to be much to their liking, and established homesteads, staked out lands, and often eked out a simple living by cultivating the fertile soil and planting crops, primarily potatoes and strawberries. At one time, the valley was as renowned for its potatoes, as other areas, such as Idaho, are today.

When the status of silver was slowly diminished through a series of legislative changes from 1873 to 1900, a gold standard was formally adopted. With the crash of the silver standard, many of the early communities sunk into decline.

The area also became renowned for its beehive-shaped coke ovens (kilns), which were built in 1884 by the Aspen Smelting Company. They were located on the J.B King and later Emery Arbaney property (called Arbaney Ranch), in what was part of the original Frying Pan Settlement/ Junction (often just called Frying Pan). By the late 1880s, the coke ovens ceased operations as charcoal was discovered in the Crystal River Valley and most of the settlement residents moved across the river to the area where the downtown Basalt exists today.

The most significant change happened when the Colorado Midland Railway shut down on August 5, 1918; most of the employees were released and no more trains were scheduled to run. Scrapping of the line and final service was delayed until 1922 in the hopes of a purchase and revival by another railroad (such as the Santa Fe), which did not occur. A D&RGW timetable (shown on page 98) from 1922, with a stop in Emma, Colorado, may very well be among the last vestiges of the rail passenger service before its demise.

As the need for the railroads declined, and the freight and passengers they brought ceased to arrive, the Mid-Valley became defined by abandoned depots and railroad tracks. The once vibrant areas of Basalt entered years of decline, decay, and uncertainty. By the time the Great Depression arrived in 1929, Basalt, like much of the country, was already struggling.

What was once a vast open area with mostly uninhibited sightlines, broken occasionally by mountains and hills, had become dotted with structures. Fortunately, unlike the urban sprawl, which overran many places around the country, fairly strict zoning laws and a desire to maintain a semblance of tranquility, ensured that most Mid-Valley projects never exceeded two or three stories.

In 1899, the State Legislature authorized $40,000 to construct a wagon road from Denver to Grand Junction (later Highway 70). The road ultimately cost $60,000, and half that cost was spent in Glenwood Canyon alone. Early 20th-century motorists reveled in the canyon's grandeur. This could be a week trip, but a drive through the Glenwood Canyon, was always cause for excitement and adventure. Even today, it is one of the most scenic rail and automobile routes in the world, as it wends its way through mountain passes, peaks, along the river, and past a plethora of terrain, forests, and valleys. With progress comes inevitable changes, and in this photograph, visitors are now motoring their way to the Valley, though the roads remained narrow, winding, and dangerous. Today, I-70 covers this path, but not without some of the same perils, such as rock slides and floods.

Homesteaders, in the area near the present downtown Basalt with Basalt Mountain behind, prepare a home site as one removes a fallen tree from the Roaring Fork River. This view is most likely just below the confluence of the Frying Pan and Roaring Fork. The one man, foreground right, appears to be wearing a military uniform. This was taken around the same location as the photograph on page 12, after some progress had been made.

While years and moisture have taken their toll, the cover of Nellie Clough's Teacher's Register for the El Jebel, Eagle County School District No. 7, for the 1909–1910 school year is priceless. The interior has the names of her students, attendance for morning and afternoon, tardies, and the grades. As an educator since 1975, the author has many of his past grade books; by comparison, the general format has changed little in the past 100 years.

Members of the Gerbaz family, longtime Valley residents, pose for a traditional portrait, taken around 1890. From left to right are Matriarch Matilda, father Everett, Neice, and Oreste. Like most of the photographs of the period, family members wore their traditional finest and the photographer either posed them before a backdrop or a staged area of the home. Note Matilda with a small bouquet in hand, Everett with a boutonniere, Neice, with a flower at her waist, and Oreste with his lapel boutonniere and book in hand. These photographs harken back to a more classic and refined time in history. (Photograph courtesy of Lois Arbaney and the Arbaney Family Collection.)

An engineer and fireman sit on the front of the engine, whose ID plate and number are not visible. Behind them is the freight car, No. 2281. This view appears to be to the south. (Photograph courtesy of Lois Arbaney and the Arbaney Family Collection.)

This postcard photo of the students and faculty from the old Basalt School was taken around 1910. All those in the photograph are deceased, and the author has been unsuccessful in finding locals, many of whom are in their 80s and 90s, who have been able to definitively identify the subjects. It still remains a wonderful piece of Basalt memorabilia. (Photograph courtesy of Lois Arbaney and the Arbaney Family Collection.)

The family of Kelly Cerise, pioneers in Basalt and the Roaring Fork Valley, gather for the wedding photo in 1910. There were many Cerises in the area, some of whom were not related, so members of the families sometimes married, as they did on this joyous occasion. From left to right are (first row) Darphine, with baby Ella on her lap, John, Kelly, the groom, Eva Cerise, the bride (and a Cerise before the marriage—one wonders if she became Cerise Cerise), Eva's sister, Georgina, who later became Kelly's second wife upon Eva's passing, and Mela—Eva's brother; (second row) John Cerise, father of the bride, Ermine, mother of the bride, Joseph, father of the groom, and Emily, mother of the groom (maiden name Tisseur and sister to former Basalt Mayor Leroy Duroux's grandmother, Rosina). (Photograph courtesy of Lois Arbaney and the Arbaney Family Collection.)

A bridge in Glenwood Canyon, bordering the Colorado River, which is raging below is seen here. The road on the right will later become a portion of today's I-70. A feat of Herculean proportions, the construction of the highway literally required "moving mountains" and blasting tunnels for the traffic, which now provides one of America's most scenic routes from Denver west, to Glenwood Springs, and then a cut-off on the present Highway 82 to Carbondale, Basalt, Willits, Emma, Old Snowmass, and up-valley to Aspen.

You can almost hear the sound of the triangle alerting the crew that "it's time for vittles." Laborers gather around their pots, pans, and plates to partake in a mealtime break from the often arduous work of building a community. In a much more formal era, even manual laborers wore ties with their suspenders, which weren't a fashion, but a necessity.

A group of surveyors toils around a work bench, with a fence clearly visible in the background. This photograph was taken in the same general area as some other Basalt views of the mountaintops, and shows how work is progressing.

Wagonloads of miners and farmhands make their way along the Frying Pan River and Road near an outcropping of rocks, probably closer to the current Ruedi Reservoir. At the time of this photograph, this journey was most likely a full day's adventure, or more, out and back. Trails could be treacherous, the river could rise precipitously in spring, blocking the roads with flotsam and jetsam, and wildlife was abundant. Settlers had to be on the constant lookout for creatures they could hunt and eat, and cautious about creatures that could hunt and eat them.

In one of the most iconic photos ever taken of Basalt, around 1915, the view shows the Midland Spur with the rail yards where Lions Park is located today. A passenger car sits idle on the Colorado Midland tracks to the left, while engine 23 and another are readied for service; a third locomotive is visible behind the building. A freight car is up on the riser for service and other

freight and passenger cars are in view. In the background of the shot, to the right of tracks, are the second depot and Frying Pan Inn. Within a few years, the tracks and railroads would be gone. (Photograph courtesy of Lois Arbaney and the Arbaney Family Collection.)

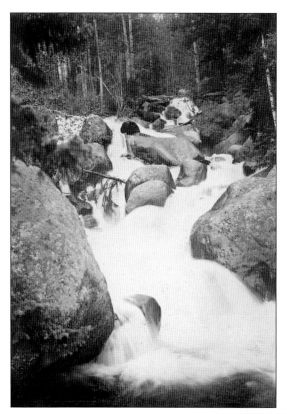

There is no shortage of world class scenery in the Roaring Fork Valley, and this exquisite view of a raging waterfall, up the Frying Pan River on the road to Ruedi Reservoir, is an example of why so many chose to place their roots in the Basalt area. These waters flow to the confluence of the Frying and Roaring Fork Rivers in the heart of downtown. Further west, near Carbondale and Glenwood, they merge with the Crystal and Colorado Rivers to make for some of the country's finest hiking, rafting, and Gold Medal fishing spots. Basalt is playing host to Regional and National US Fly Fishing Championships in 2013.

W.H. Harris (at the wheel) with his passenger, believed to be Frank Delancy, are shown in this 1907 photograph, taken in front of the Hotel Glenwood. (Photograph courtesy of Lois Arbaney and the Arbaney Family Collection.)

William Henry Harris, a Basalt pioneer and icon, is shown in his wedding photograph to Mollie Carey. The wedding took place on January 31, 1884, at St. Mary's Catholic Church in Aspen, and was officiated by Reverend Edward Downey. (Photograph courtesy of Lois Arbaney and the Arbaney Family Collection.)

Posing in front of what was once the Sundry in downtown Basalt, this photograph from 1917 shows members of the family is their best attire, which certainly wouldn't stay clean very long, considering the unpaved gravel roadbed in which they stood. (Photograph courtesy of Lois Arbaney and the Arbaney Family Collection.)

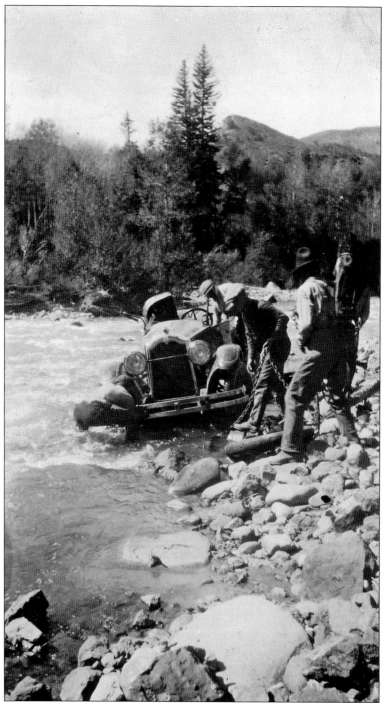

While the author has their identities, the names shall remain anonymous due to their car ending up in a river after a night of partying and drinking. While two men work to prepare the car wheels, one prepares the tow hitch with chain and block, and the fourth man steadies the "tow truck," then known as the horse. (Photograph courtesy of Lois Arbaney and the Arbaney Family Collection.)

Irena and Vincent Harris ride the running boards of the car in this 1929 photograph. They were looking pretty dapper during the year the Great Depression began. (Photograph courtesy of Lois Arbaney and the Arbaney Family Collection.)

Ralph Harris and Alice Ida (McCarthy) Harris pose proudly for their wedding photograph on April 18, 1911. (Photograph courtesy of Lois Arbaney and the Arbaney Family Collection.)

Vast areas of Basalt, such as this early photograph of the Arbaney Ranch, show the size of farming or ranching operations. In the background, the bee-hived shaped structures, which look like the kilns, are actually large bales of hay. (Photograph courtesy of Lois Arbaney and the Arbaney Family Collection.)

Laurent Arbaney Sr. and Mary Rolin Arbaney pose on their ranch property in this photograph. They were the parents of Alex, Eva, Laurent Jr., Alice, and Fierman Arbaney. (Photograph courtesy of Lois Arbaney and the Arbaney Family Collection.)

The attractive Basalt home of the Harris family is seen here. While this beauty no longer exists, the victim of a common malady of the time, fire, other similar historic homes and structures still survive in the area today, including the Sloss Building, the Smith property, and portions of the old church. Today, each of the aforementioned buildings has been renovated for residential and commercial usage, and are accessible through an alley walkway directly north from Midland Avenue downtown. The church, which has a modern addition, was converted to a mixed-use residential/commercial building and, as of the spring of 2013, was on the market for sale.

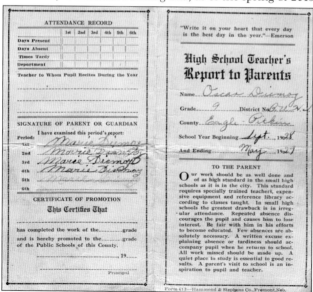

Oscar Diemoz's ninth grade report card from the 1928–1929 school year indicates that he was a pretty good student. Although the card does not provide the name of his teacher or a certificate of promotion, it is signed each period by his mother, Marie, and we know that Oscar did succeed and move on to the Basalt Union High School. (Photograph courtesy of Lois Arbaney and the Arbaney Family Collection.)

Three

WHERE ALL PATHS MET

Hearty families who settled in the area began raising their families, buying acreage, creating ranches, farms, and tapping water supplies from the rivers and numerous streams, creeks and tributaries, which spread far and wide. These pioneering families established new businesses, built new industries, and created new opportunities for others to follow. Today, the names of the Arbaney's, Granges, Duroux's, Gerbaz's, Kittles, Harris's, Luchsinger's (later Lucksinger's), Fiou's, Brown's, Willits', Hyrup's, Cerise's, Nash's, Fornier's, Jacob's, Sloss's, and others are forever linked with Basalt history, many with streets and areas named after them.

In the early 20th century, as the new town population grew, infrastructures were needed to serve the area's constituency. In the summer of 1901, the Town of Basalt was formally incorporated (though the name had already come into common use) and served as the mid-point and the epicenter of the Roaring Fork Valley, connecting Aspen to Glenwood Springs. The first municipal election was held in October 1901, and today, a document certifying the results of that election hangs in Basalt Town Hall.

With the departure of the railroads, and without an extensive or effective transportation system connecting the two major cities at each end of the Roaring Fork Valley, traversing the valley became an all day (or more) affair. With 27 miles from Glenwood to Basalt, the town became a stopping place before continuing to Aspen, another 20 miles to the east. Until just recently, the former railroad tracks and ties of the railroads remained extant. Once the electorate decided against a high-speed rail system to connect Glenwood and Aspen in the early 2000s, the last of the railroads and their grand history were gone, relegated to collections, museums, and people who cherished the artifacts.

Roads were dusty, pothole ridden, and difficult to navigate. Building a new highway was a major political item for decades before things were settled, and, slowly, Highway 82 was paved in the 1970s, and then expanded to four lanes, including the road through Snowmass Canyon, in late 2004.

As of 2013, the Basalt Chamber of Commerce is located in a donated historical caboose in Lions Park. While it was not one of the cars that made its way to Basalt during its years in operation, its presence in the park, at the town's most visible intersection of Midland Avenue and Two Rivers Road, serves as a tangible reminder of the days when the railroads merged in the heart of town.

Today, with the exception of some historical buildings and placards placed by the Basalt Regional Historical Society (many in need of repair or replacement) at some key locations, there are too few reminders of the origins of historic Basalt.

AN UNPLEASANT SURPRISE

John Henry "Hy" Hintermeister (1869–1945) was renowned for producing numerous calendars, jigsaw puzzles, and oils on canvas depicting the American lifestyle. His style, often reminiscent of the great Norman Rockwell, is seen here on the cover of a 1939 Basalt calendar titled "Unpleasant Surprise," as our elderly fisherman friend is ridiculed by his fellow, younger anglers, for what may well be the smallest catch of the day.

Surveyors huddle around the tent in the area of Emma. With plenty of predators nearby, including bears, coyotes, mountain lions, and bobcats, plus a plethora of other wildlife, having a rifle handy and your trusted canine pal made perfect sense. The rivers provided fish and beaver, and the land was rife with elk, deer, wild turkey, and other creatures of the mountains.

Born in Aspen, Colorado, this handsome young fellow's family later moved to Basalt, where he served the Town for 17 years as a Councilman and Mayor. Leroy Duroux and his lovely wife, Janice, who have been instrumental in founding and leading the Basalt Regional Heritage Society and were contributors to this book, have remained pillars of the community. Today, hardly an event, program, or activity will pass without Leroy present, continuing his acts of service and philanthropy.

CENSUS LIST NO. 1

191͞5͞

District No. ͟7͟

͟͟͟͟͟͟͟͟͟͟͟͟͟͟͟͟͟ *Eagle* ͟͟͟͟͟͟͟ County

INSTRUCTIONS.

1. This census blank is for use in districts having a school population of less than 100 persons.

2. Sections 97 and 115 of the School Laws Annotated, 1912, should be *carefully consulted* for directions. The age on last birthday prior to February 10th should be given.

3. Place names of boys on left-hand page and those of girls on right-hand page in alphabetical order.

4. The names of all persons between the ages of six (6) and twenty-one (21) years should be given. In districts below first class, under residence, enter name of parent or guardian and post-office address. Enter on separate list in back of this book each deaf mute or blind child between the ages of four (4) and twenty-two (22) years, with name and postoffice address of parent or guardian.

5. In calculating the numbers between 6 and 21, 8 and 14, the first number only in each case is to be included.

6. Students in a private or public institution, whose parents are non-residents of the district in which such institution is located, should *not* be included in the census of that district.

7. This list must be taken, sworn to and filed with the county superintendent on, or before, the *first day of April*, of the current school year, or the district will forfeit its money for the ensuing year.

Shown here is the cover of the Census List No. 1, Eagle County, Colorado for El Jebel, Emma, and Basalt, from 1915. The entire children's book consisted of two pages of hand-written names with ages. It is likely the census was still in progress at the time this version was acquired.

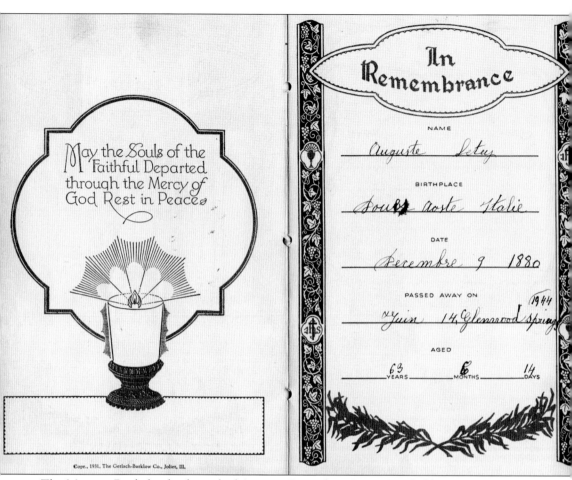

May the Souls of the Faithful Departed through the Mercy of God Rest in Peace

Copr., 1931, The Gerlach-Barklow Co., Joliet, Ill.

In Remembrance

NAME
Auguste Setey

BIRTHPLACE
Douro aoste Italie

DATE
December 9 1880

PASSED AWAY ON
1944
oe Juin 14, Glenwood springs

AGED
63 YEARS *6* MONTHS *14* DAYS

The Memory Book for the funeral of Auguste Setey, from June 1944, held at Farnum's Home Mortuary in Glenwood Springs is shown here. Mourners came from as far away as Leadville, Colorado, (on the other side of the Continental Divide) and included some recognizable Basalt and Valley pioneering names such as Cerise, Grange, Arbaney, Berthod, Arlian, and Gerbaz.

Members of the class of 1948 pose in front of the original Emma one-room schoolhouse, the last year it functioned as a school. Teacher, Mrs. Kulmer (rear top), looks to Les Dossigny (seated far right and looking back at her). Other students include, from left to right, (first row) Jack Jowell, Jim Russo, Buddy Cerise (holding Jimmy Grange) Paul Jowell, Betty Castle (holding Shirley Rhodes) and Les Dossigny, (second row) Larry King, Beverly Vasten, John Vasten, Arlene King, Sharon King, Mary Williams, Judy Williams. The building, which was maintained for many years by the Basalt Lions Club, still stands as a testament to the pioneering days of the area. The 15 students in the class encompassed all ages from kindergarten to high school, many members of the same family. This was truly an example of the adage "It takes a village to raise a child."

NORAMA OF BASALT, COLO.

This wonderful 1945 Sanborn postcard photograph looking to the northwest encompasses much of current downtown Basalt, from the Frying Pan River and Arbaney Park, where the Coke ovens are visible in the foreground, toward Lions Park (the small triangular piece of land), and the location of the former Denver & Rio Grande Western Railroad and Colorado Midland Railway's yards and repair buildings. Today, near the corner of Midland Avenue, the former Basalt Bank, now Alpine Bank, a wonderful community partner, sits in the second railroad depot building.

A historical plaque in front of the bank commemorates the site (along with some of the original rails, which have been re-imbedded in place). Clearly visible are the areas of Homestead Drive and residential development north of downtown, including the old church, Sloss and Smith Buildings, and Victorian house. To the right is Frying Pan Road. Cars can be seen on Midland Avenue in downtown; many of the streets remained unpaved until the early 1970s. (Photograph courtesy of Lois Arbaney and the Arbaney Family Collection.)

Seen here is a Colorado Midland Bill of Lading from 1915. Note that the rate was in cents per pound. Today, that is likely to be dollars per pound. These were required paperwork for all freight operations. The end of the railroads in the Valley was in the near future. (Photograph courtesy of Lois Arbaney and the Arbaney Family Collection.)

The Historic Snell Building (triangular roof) at 104 Midland Avenue, at the Midland Spur, across from what was once the train yards, has been restored. It is now part of a larger structure, with more modern facets added, comprising a mixed-use commercial and residential property. In the lower portion of Snell is a locals' favorite coffee shop serving breakfast and lunch, Saxy's Café.

In 1933, a group of children pose for a photograph at the old Luby School, one of several which sprung up in the valley. Many children were homeschooled and because of the challenges of transportation, schools were small, but plentiful in Basalt, El Jebel, Emma, Willits, Aspen, Carbondale, and throughout the Valley. (Photograph courtesy of Lois Arbaney and the Arbaney Family Collection.)

Members of the Arbaney family gather at the ranch in 1946 in this photograph taken by Bert Allred. From left to right are Laurent Arbaney Sr., Irena Arbaney, Mary Arbaney, Kelvin (age 4), Alice Arbaney Allred and son Ralph (age 6), Alex Arbaney, Laurent Arbaney Jr., and Fierman Arbaney.

In this photograph from the archives of the Aspen Historical Society, local John Bowman and two other unnamed gentlemen gather at the end of a day's prospecting for a congenial drink (probably bourbon or whiskey) and a smoke. This shot was taken at the base of Smuggler Mine in Aspen. (Photograph courtesy of Alpine Bank and the Aspen Historical Society.)

Four

SLEEPY TIME
AND SLEEPY TOWN

As the heydays of mining and logging ceased, many of the towns and cities in the valley fell into a twilight sort of limbo. With no large industries, and the no transportation available to move potatoes, cattle, silver, logs and other freight in and out, Basalt became a much quieter place, yet one which many locals love to recall. It was a calmer, more genteel, laid back time, and ideal for raising a family.

The reality of the lingering hard times of the post-Depression era, the callings of the Second World War, a postwar laissez faire approach, and lack of viable commercial infrastructure left Basalt in limbo.

As the late 1940s and 1950s gave way to the tumultuous 1960s, many Basalt businesses and institutions struggled to maintain a foothold, and as pioneers passed away or moved on, newer residents didn't always embrace the same desire to preserve some of the town's history and character.

Many of the structures built during this period weren't particularly appealing or attractive. Unlike buildings that captured a prevailing architectural style, such as Victorian, Art Deco, or Frank Lloyd Wright's Usonian, the properties constructed during the 1940s through the early 1970s, were simple concrete block, boxy, and mainly utilitarian, often referred to as Shed Style, which they resemble.

Some of the structures in downtown, most notably the Basalt Motel, now called the Green Drake, and the current building, which houses the Two Rivers Café, Midland Shoe Company, and Corky Woods (three wonderful community businesses), are reminiscent of that style. The Green Drake—A Motel (its sign actually reads this way) and the Aspenalt Lodge are the only two lodging properties currently operating in downtown Basalt and are reminiscent of a quieter, bygone era.

While smaller hotels and motels, such as the aforementioned, have maintained a certain appeal and hark back to a different era in the life of the town, most all agree that Basalt needs some viable new lodging facilities to house visitors and guests.

With renewed energy in the retail, commercial, and residential cores of Basalt and Willits, and the vibrancy created by the Basalt Chamber's extensive marketing and advertising efforts, there is new focus on Basalt as a destination resort. At least two new boutique hotels are planned (one in downtown Basalt and one in Willits, along Highway 82) and these should come to fruition within a few years of the publication of this book.

Another area, just west of the original town, is still called Aspen Junction. While not at the site of the original settlement, it is a residential area, which lies just off Two Rivers Road, along the Roaring Fork River. It is bordered on the north by the Basalt Wildlife Open Space area and on the south by Highway 82.

A soiree along the Frying Pan River on the dirt road (now Frying Pan Road) may have involved some rest, relaxation, fishing, and scenery. Notice the old bicycle on the right. However, unlike the rides from downtown along the modern, paved and wider two-lane version today, this journey would have been a full day venture. This is the same route the railroads once took toward Ruedi, Woody Creek, and Lenado, up to Hagerman Pass and Leadville on the Midland Route.

Taken in March 1939, from the collection of William E. Ray, the former Frying Pan Inn, later Midland Hotel, is the current Tempranillo Restaurant, in the heart of historical downtown Basalt. Downtown was very different from its railroad, mining, ranching and farming heydays, and at the time there was little else surrounding the property on the south side of Midland Avenue. Many portions of the building exterior remain much the same, though the interior has undergone numerous reconfigurations over the years to reach its current role. Today, the Basalt Chamber of Commerce and Basalt Arts and Social Happenings (BASH) committee hold monthly Second Saturday street fairs and events in front of this location and in Lions Park. (Photograph courtesy of Lois Arbaney and the Arbaney Family Collection.)

This postcard from the early 1970s shows the former Basalt Motel, now the Green Drake. The property is located directly across Midland Avenue from the author's real estate office, and visible out his window. The property was slated for redevelopment in 2008, before the market depression, for a mixed use, commercial/residential and office/retail complex, which may yet come to fruition. (Photograph courtesy of Lois Arbaney and the Arbaney Family Collection.)

The cover of the area telephone directory for 1943 included the entire Roaring Fork Valley from Aspen to New Castle, including Basalt, Carbondale and Glenwood Springs. Note the Bell Telephone System symbols and a prominent front-page ad by Farnum Mortuary, with its two-digit phone number, 45. The author has some vintage Basalt items with single digit phone numbers. There is also an ad tag attached for Sally Ann white sliced bread.

59

This 1950s view of downtown Basalt by Ed Greenwood, looking to the east, clearly shows Lions Park in the foreground, with a large semitrailer truck on the left, in front of the Snell Building. Just beyond are the one time Texaco station and the Midland Mall building. The Kelly Block and W.W. Frey Buildings from 1900 are still visible on the left as well. Many other buildings

on that side were demolished to make way for newer structures. Just beyond, where the truck and trailer sit, is the site of the former depot. A liquor store sign and the Frying Pan Inn, now a restaurant, can be seen in the background. (Photograph courtesy of Lois Arbaney and the Arbaney Family Collection.)

RIVER VIEW, BASAL

The old entry bridge into Basalt was closed to vehicle traffic when the new bridge at Midland Avenue was built to accommodate cars, buses, and pedestrians. This bridge was recently renovated through a joint effort between the town and citizens (many of whom volunteered to do landscaping work and improvements). It now serves as an attractive bicycle trail and pedestrian path, leading from the Basalt Avenue intersection to east Two Rivers Road, near the site of the current Basalt Elementary and Middle Schools (and the former Old Brick School from the 1930s on the same location). (Photograph courtesy of Lois Arbaney and the Arbaney Family Collection.)

The two photographs shown here (above of the fifth and sixth grade, below the Intermediate class from 1946–1947) are of the Basalt Union School's classes from the 1940s, and seem to evoke memories for all who view them, pointing out their faces, friends, and family members. Many of the pioneering names still associated with the town today are present in the photos, such as Cerise, Arbaney, Stutsman, Gerbaz, Willits, Crawford, Hyrup, Duroux, and more.

The above image is of a primary class of 1945–1946, and below is an intermediate class of 1947–1948.

Above are Basalt teachers for the 1945–1946 school year as they pose proudly for the photograph. From left to right are Miss Needham (later Mrs. Ravoux), first and second grades, Mrs. Malforde Rapini, fifth and sixth grades, Mr. Williams, High School, Mrs. Williams, High School, and Mrs. Sweet, third and fourth grades. The below image shows grades five and six in 1949–1950 school year.

Several miles east up the Frying Pan from downtown are the Seven Castles. Their unique rock structures, resembling medieval castles, have become world renowned and are now the site of attractive homes. This is a westerly view, looking back in the direction of town, which is not visible. There is a large indigenous population of protected Bighorn sheep in this area.

Another view of the spectacular area of Seven Castles, once referred to as Red Rock Canyon, is shown here.

John Letey, grandfather of former Mayor Leroy Duroux, is shown with his stud horse. Letey traveled throughout the valley to provide equine stud services. This photograph, believed to be from the early part of the 20th century, was taken at the old Emma store building.

BASALT SUPPLY CO.
BEN P. DARIEN, Prop.
Groceries and Hardware—Stock Salt and Feed
School Supplies, Dry Goods, Notions, Candy
Phone 2171

Basalt, Colo., *Jan* 1 195*7*

Name *Diemoz Bros.*

Address_____ Account Forward

Quan.	ITEM	NO TAX	TAXABLE
	Dee Acct.		24 89
	Acct to Dee 1		80 49
			$105 38
	Paid In full		
	M D		
	25		

Your Account Stated to Date—If Error Is Found Return at Once.
10% Interest Charged On All Accounts Over 30 Days.
474502 NEBRASKA SALESBOOK CO., LINCOLN, NEBR.--DENVER

A bill of sale from Basalt Supply Co., Ben Darien, Proprietor, shows the account of the Diemoz Bros. paid in full on January 1, 1957. The Darien's still maintain an apartment in downtown. The Basalt Supply Company, much like our major grocery stores today, handled the accounts of most of the areas families. While too old and fragile to handle for reproduction, the author has viewed the old company records that go back over four decades. All hand written, it is a virtual history of a town's shopping habits.

Oscar Diemoz, who graduated Basalt High School in the spring of 1934, is shown in this 1933 photograph, proudly wearing his Basalt letter sweater.

The Colorado Cattlemen's Association membership card of the Diemoz Brothers, with dues paid through November 11th, 1958, is shown here.

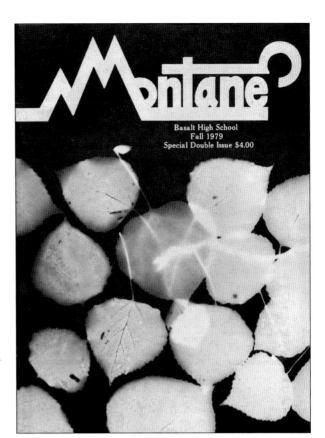

Copies of *Montane*, the Basalt High School magazine from 1977–1982, provide some interesting and unique insights from the students at the time, often including historical perspectives of Basalt.

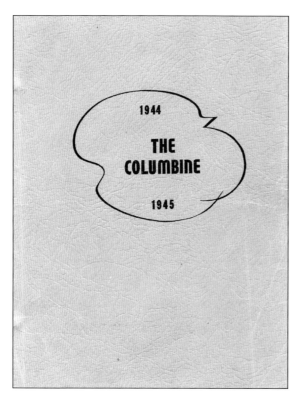

Copies of the Basalt Union High School yearbooks from 1946, 1953, and 1958 are a reminder of the unique times gone by in the life of a town. The war years' versions were done on paperback stock due to the scarcity of materials during the war.

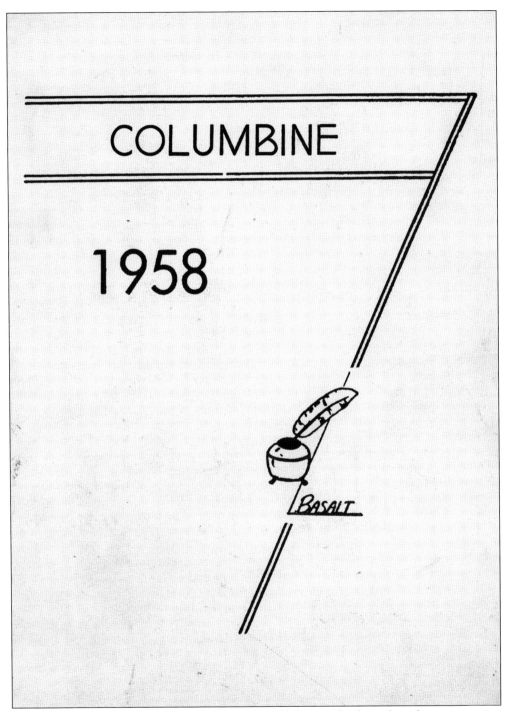

The later versions are hard cover with glossy paper. Today, yearbooks such as these are moving to DVD, and even online versions.

THE SPUD CITY SENTINEL

THE CHEAPEST PAPER IN CARBONDALE ABSOLUTELY FREE
PUBLISHED BY THE CARBONDALE COMMUNITY
CHAMBER OF COMMERCE
VOLUME 1, No. 3

SOD-BUSTING SEASON IN THE VALLEY

by Rosalee Holgate
as told by
John Arbaney

In the early 1900's, agriculture was the main livelihood in Carbondale. Potatoes were the main crop followed by cattle raising and grain.

This is the time of year the farmer was busy preparing his soil for spring planting after the ground had been plowed in the fall. Planting was done in May for potatoes with grain planted as soon as the frost was out of the ground long enough—usually sometime in April.

The big producers of potatoes in those days were the Crystal River Ranch which raised between 150-200 acres of spuds per year. The Big Four Ranch (Four Bar Ranch) raised about 75-100 acres. For the most part, however, the farmers in the valley averaged around 15-20 acres of some of the best potatoes in the country.

Missouri Heights was also an important farming area and approximately 1000 grain cars of potatoes were shipped from the Heights and Carbondale area each year. With 450 sacks to a car, they were sold at times for 25 cents a 100-lb. sack.

Most of the farm work was done by hand and horse-drawn machines.

School was dismissed for at least two weeks in the fall for potato harvest with most of the youngsters out in the fields picking spuds for 3 cents per 100 lb. sack. The kingly sum of $3 was paid for picking 10,000 pounds of potatoes--then again, that was before inflation but it wasn't easy work.

Grain was also a very important crop for the local farmers.

Each farm had almost as many acres of grain as potatoes with the grain usually harvested in late August or early September.

The grain harvest was a combined effort of all the farmers who would take the thresher owned by one and go from farm to farm

con't on pg. 3

Shown here is The Spud City Sentinel, "The Cheapest Paper in Carbondale ABSOLUTELY FREE," published by the Chamber of Commerce. While comparatively more recent than many of the materials in the book, this 1950s paper still harks back to the days when Carbondale, Willits, Emma, and Basalt were huge purveyors in the potato industry. Today, neighboring Carbondale still celebrates its past with the Annual Potato Days Festival.

Alfred P. Hyrup, of another of Basalt's longtime families, stands in front of the old Basalt School. Many of the Hyrup family still live in the Basalt, Willits, Emma, and El Jebel areas. Family member Steve Hyrup used to own the Hyrup Feed and Supply Store on the Crawford's property in El Jebel for many years.

Ever in danger of flooding, areas of Basalt on the Roaring Fork and Frying Pan have been designated as flood plains and are in serious danger should the town ever experience a large flood. Much of the danger relates not to how much snow the area receives, but the rate of snowmelt and runoff in the spring. This 1957 high water photograph of the old Basalt suspension bridge, which was later destroyed, clearly indicates just how high the waters can rise in a dangerous situation. In 2010, though not a particularly large snowfall season, the quick change from winter to summer conditions in the spring, led to a rapid runoff and threats of flooding.

What appears to be a simple down valley view actually provides greater insights into the size of some of the homesteads and ranches in the Basalt area. On the right, there are corrals and fenced areas for horses and cattle, looking out to fields and pastures. To the left are the tops of what appear to be barns and a home. It is more than likely that this was a ranching property, probably in the area of the current Blue Lake, Cerise Ranch, or Willits. The fence in the foreground may have indicated another pasture or adjacent property.

Five

BUILDING TOWARD
A BETTER BASALT

While the area has seen economic highs and lows, the economy of the Roaring Fork Valley continued to improve through more than two and half decades.

Many factors influenced these economic improvements. The skiing industry growth, cultural influences, demand for family oriented recreation activities, more accessible transportation, including improved or new airports, an improved Interstate highway system, and expansion of Highway 82 throughout the Valley, were among the positive influences.

Basalt, while still a well-kept secret, was becoming one of the most desirable places to live in the United States. It has received recognition in the New York Times, various food and wine magazines, sports and athletic publications, and lifestyle sections of the *Denver Post* for its unique character, wonderful amenities, fabulous fishing, excellent dining, quality of life, and fine galleries. Speaking of fine galleries, the author would be remiss if he failed to mention the renowned Toklat Gallery, Ann Korologos Gallery, and Wyly Community Arts Center in the heart of downtown Basalt.

In the real estate realm, influenced by many of the factors above, land and homes in the Valley skyrocketed, making local properties among the highest valued in the nation. The new ArtWorks Gallery opened in midsummer 2013.

The area demographics began to change as well. A population, which for many years included ski-bums and college students of the 1960s and 1970s, had begun to morph as they married and had children of their own. Some remained and continued their family legacy here and some moved away. But, to fill the demand for employees, the area drew new, diverse populations, which included Hispanics, Asian-Americans, African-Americans, and seasonal employees from Europe, Australia, New Zealand, and South America.

As the United States and the world began its slide into a second lengthy depression, which began in 2008 and is still being felt today, Basalt too experienced severe financial difficulties. Throughout the Valley, many town storefronts were vacant, numerous businesses were forced to downsize or close, and even some local non-profits, such as Aspen Youth Experience, which were unable to maintain their fund-raising bases, were forced to close their doors.

For a community accustomed to prosperity, it was a difficult and trying time.

In this 1994 article by Oscar Diemoz and family from the *Valley Journal*, a photograph shows the students at Basalt's first school, around 1890. The younger students sat in front of the older students, and the teachers are in the center, in the back row. A notice from the first principal, J.H. Troendly, dated August 27, 1904, announced the opening of the schools that year.

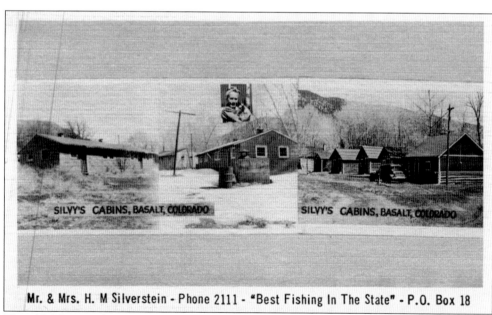

The old Silvey's cabins in the area off Riverside Drive, run by Harold and Grace Silverstein, were once popular tourist destinations next to the Frying Pan River, which offered the "Best Fishing in the State." They were located near the Luchsinger and Arbaney properties, just off the east end of Midland Avenue, in what was the original Frying Pan settlement before Basalt proper moved to its current location downtown. (Photograph courtesy of Lois Arbaney and the Arbaney Family Collection.)

This small Polaroid-style photograph of George and Grace McLaren was taken by Margaret Cerise in June 1966, near the northeast corner of the McLaren's Basalt home. According to the personal inscription on the back, this was the last photograph ever taken of George and Grace. (Photograph courtesy of Lois Arbaney and the Arbaney Family Collection.)

The sleepy little hamlet of Basalt, Colorado, was incorporated in the summer of 1901. This view, taken from the area of today's Arbaney Park toward the west, encompasses portions of downtown, Lions Park, Homestead Drive and the current Two Rivers Road as it snakes its way down valley. The railroads were gone and Basalt's heydays were in the past. The Frying Pan Inn, and some of the other remaining buildings after the railroads departed, are still visible. (Photograph courtesy of Lois Arbaney and the Arbaney Family Collection.)

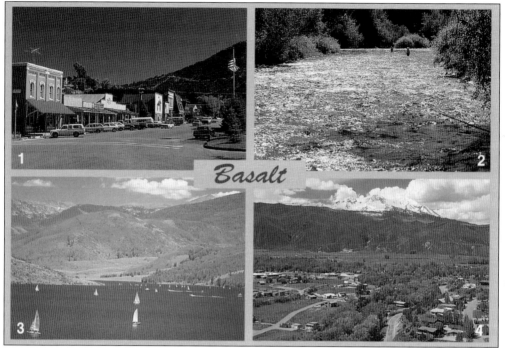

A postcard of downtown Basalt with four numbered scenes in the 1960s is shown here. The scenes are as follows: 1) Downtown Basalt 2) Fly-fishing on the Frying Pan 3) Beautiful Ruedi Reservoir 4) A view across town south to Mount Sopris. (Photograph courtesy of Lois Arbaney and the Arbaney Family Collection.)

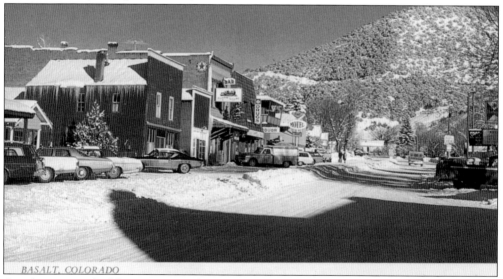

Another postcard of downtown Basalt in winter, probably taken around the same location as the No. 1 image on the above postcard, is seen here. This was a time before alcohol advertising had been banned, and many of the images of this era have advertisements for Coors, liquor, Budweiser, and bars. Other items of note are the Basalt Motel on the left and the former Silbey's Cabins in the background (right). (Photograph courtesy of Lois Arbaney and the Arbaney Family Collection.)

Laurent Arbaney Jr. and Fierman Arbaney pose proudly in front of the old barn in this 1986 photograph. (Photograph courtesy of Lois Arbaney and the Arbaney Family Collection.)

This is a view of the new 1938 school, with the old school still partially visible to the right and a late 1930s model Ford pickup sitting just inside the fence to the right.

COLORADO MIDLAND YARDS, AT BASALT, COLORADO.

This postcard features the downtown train yards and offers an exquisite view of some of the homes on High Street and Second Street, the Block building, and the church steeple. Engines 301 and 304 sit with accompanying freight cars as cars 303 and 305 await work in the facility. (Photograph courtesy of Joe Moore and the Brass Whistle.)

Farming had become modernized by the time this 1928 image was taken of a steam tractor pulling some equipment with members of the Gerbaz family at their ranch. (Photograph courtesy of Carolyn Cerise-Barabe and the Cerise Family.)

Auzel and Mike Gerbaz Sr. till the land on the Gerbaz Ranch. (Photograph courtesy of Carolyn Cerise-Barabe and the Cerise Family.)

The Gerbaz family home in 1899 with five members of the family posing in front with the family dog is seen here. Notice the carriage to the left. (Photograph courtesy of Carolyn Cerise-Barabe and the Cerise Family.)

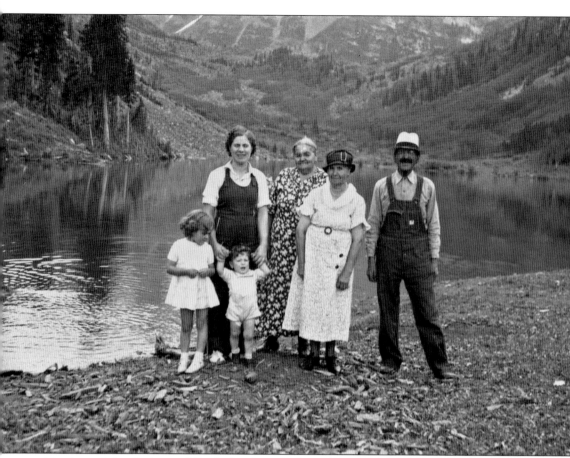

Members of the Gerbaz and Brady families—Dolores, Eva, Doug, Cesarine Brady, Cecile, and Jeremie—are seen in this 1937 photograph taken at Maroon Bells Lake with the snow covered Bells in the background. Dolores still resides in downtown Basalt, and is as active as ever, hiking, smiling, and greeting all those she sees. Members of the Stutsman and Gerbaz families are still active in the community today. (Photograph courtesy of Carolyn Cerise-Barabe and the Cerise Family.)

The new and old combine in this farming view on the Gerbaz Ranch as a team of men work the steam equipment to create a huge pile of hay. Another piece of equipment is to the left as the horse and cart stand ready to the right. (Photograph courtesy of Carolyn Cerise-Barabe and the Cerise Family.)

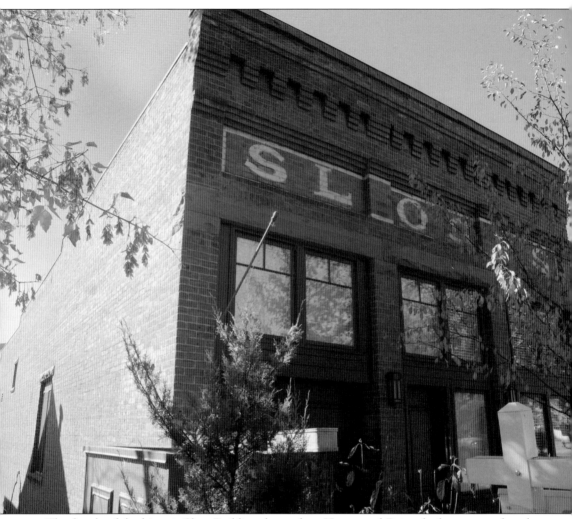

The façade of the historic Sloss Building, located on Homestead Drive, looks very much today as it did at the turn of the 20th century, with a few modern additions. (Photograph from the author's personal collection.)

TIERNEY MERCANTILE STORE
153 WEST HOMESTEAD

Mrs. Ella Tierney built The Tierney Mercantile Store in 1898. She moved her mercantile business from Main street to high street into the large brick building. She passed on this business to Elbert Gray and his son E.H. Al Gray who ran it as a family business until 1905.

In 1905 James Fillmore Sloss and his son Melvin purchased the Tierney Mercantile Store from the Gray's and continued to operate it as a mercantile store until 1918. From around 1918 until 1945 the building was leased by the school for basketball games, roller skating and other functions. At one time a thrift store was operated in the building.

In 1945 the American Legion William B. Lucksinger Post 184 and Unit 194 of the American Legion Ladies Auxiliary, purchased the building from the Gray family. The Legion organization held their monthly meetings in the building and sponsored the bimonthly town dances. They also held raffles, carnivals and other community events. During the 1970's a preschool was run in the buildings' basement and the upstairs was home to a dance studio.

Charles Cole purchased the building in November of 1993. The Coles refurbished the outside and interior of the building, establishing a residence upstairs and an interior design store, "The Verandah Collection", in the lower level.

Basalt Regional Heritage Society Walking Tour

Heritage Society placards dot the landscape at important sites, this one in front of the old Tierney mercantile, later Sloss Building. (Photograph from the author's personal collection.)

159 E. HOMESTEAD/PUTMAN HOUSE

This authentic Victorian was built in 1898. The floor plans, design, wood and every detail was ordered by a wealthy Aspen family directly from the Sears Catalog. The original cost for this Sears Kit House was under $900.00. The house originally was to be delivered by train to Aspen in 1896, but by mistake the "Kit" ended up in Basalt, since Basalt at that time was called Aspen Junction. The house sat in the Midland Train yard for two years as unclaimed freight.

The two story Sears Victorian has the original wood trim and baseboards throughout the house and has been remolded and decorated in keeping with the era. The current owners have resided in their home for 26 years and love it.

The small house in the backyard was moved from Homestead (next to this house) in 1900 with a team and logs. The house had been home to the Midland Railroad employees and the first minister of Basalt.

Basalt Regional Heritage Society Walking Tour Est 2003

The Putnam House at 159 East Homestad Drive has been restored to its former grandeur. What makes the 1898 home so unique is that it was originally purchased from the Sears Catalog and all parts were to be shipped to Aspen. However, it ended up in Basalt (then Aspen Junction), where it sat in the Midland freight yards for two years. It was then constructed at its current site. Total cost of the home at the time was a staggering $900. (Photograph from the author's personal collection.)

In Castle Creek Canon

Much like the Frying Pan Road, Castle Creek Road, near Aspen, had to be carved out of the mountains to make the current roads and by-ways, some of which are still narrow, two-lane affairs.

Six

CONFLUENCE OF RIVERS, RECREATION, AND CULTURE

Basalt's location, on what was once the old entrance to town, sits on the convergence of the Frying Pan and Roaring Fork Rivers and along the rightfully named Two Rivers Road. The rivers meet in the center of town, which saw dramatic changes when the new four-lane Highway 82 was built to the south of the original settlement.

Many came to see Basalt (at least on Highway 82) as a single primary intersection, at which there is a gas station and a national chain tire store. Unlike Willits, the area of downtown Basalt isn't viewable from the road. With the change in the entrance, known mostly to locals, few visitors understood the pathways necessary to navigate to reach this gem of a locale.

Basalt needed to develop a new character and identity. Still rife with history, it has some newer developments and a strategic vision, which is very much in keeping with its small town character.

With Lions Park (dedicated by the local Lions Club) at its heart, Basalt today has become the "Fly-Fishing Capital of North America." It proudly hosted the Team USA Rocky Mountain Regional Qualifying Fly Fishing Tournament in 2012, and the USA National Fly Fishing Championships in the fall of 2013. The town is applying to host the World Fly Fishing Championships in the coming years. As the only town in North America with two Gold Medal fishing rivers in its core, Basalt has become a year-round destination for fishing enthusiasts.

In 2010, the Chamber embarked on a new path called BASH (Basalt Arts and Social Happenings), which sponsors monthly Second Saturday street events downtown on Midland Avenue and in the park, to restore some of the economic vitality lost during the depression of 2008–2012. This new effort has been met with great participation and success, and includes antique car shows, motorcycle and bike rallies, fall festivals, themed and holiday events, food booths, merchant involvement, and activities for people of all ages.

In addition, a new Basalt Sign Committee has created attractive, new visible roadway and post-arm signs, which direct visitors, guests, and locals to its historical downtown, as well as the other areas of town. New virtual interactive visitor information kiosks and large welcome signs at the town's primary entrances are in the works.

A surveyor's campground in the area near what is today downtown Basalt, probably by what was once Frying Pan Town, and now Arbaney Park is seen here. While still an area of incredible beauty, gorgeous landscapes, nature at its finest, and sublime serenity, the pristine condition of the land is a far cry from today's community of highways, buildings, homes, and municipal infrastructures.

The Arbaney Barn, restored through the generosity and volunteer efforts of the Basalt Regional Heritage Society, as it looks today. Located in Arbaney Park, the property is also the site of the historic coke ovens, and newer amenities such as a community pool, playgrounds, and sports fields.

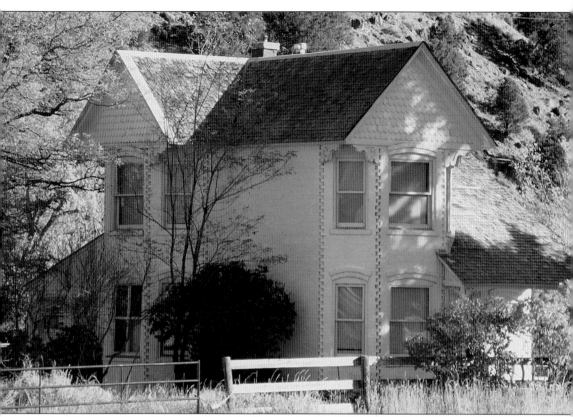

On Highway 82 in Emma is the old Victorian house and Emma Store, which now belong to Pitkin County; through State Historical funding, these buildings have received a much-needed facelift to prevent their collapse and demolition. The Denver & Rio Grande Western Emma train station, which no longer exists, passed just behind the area of the schoolhouse across the street and provided daily passenger service.

The old Emma Schoolhouse is pictured as it appears today, much the same as it was years ago, except with a few minor, modern changes, such as electric wires, a plastic step stool, some benches, and a gas grill for community events.

This wonderful c. 1900 photograph of downtown Basalt, facing west, includes a view of snow-capped Mount Sopris in the background. Some freight cars sit idle on the siding in the center and the old depot is visible on the right. The large water tower is the most prominent feature of a fairly barren landscape, about 10 years before the town was officially incorporated.

Throughout Basalt, old barns, houses, and equipment from the early part of the 20th century, an integral part of the town's storied history, dot the landscape. The Basalt Regional Heritage Society is making an effort to raise the funds necessary to replace historic plaques and many of the structures to a condition that will be more inviting to local history buffs and visitors alike. Some of the proceeds from the author's royalties of this book will go toward that effort.

This plain-looking bike path off Highway 82 and Willits is across the street from the former Emma Store and Victorian (pictured on page 92). The path covers what was once the railroad lines of the Denver & Rio Grande Western, connecting to Glenwood Springs and the west and Aspen on the east (the direction of this photograph). The former railroad station was just beyond the fences on the left. Railroad ties are sometimes still visible to cyclists on this path..

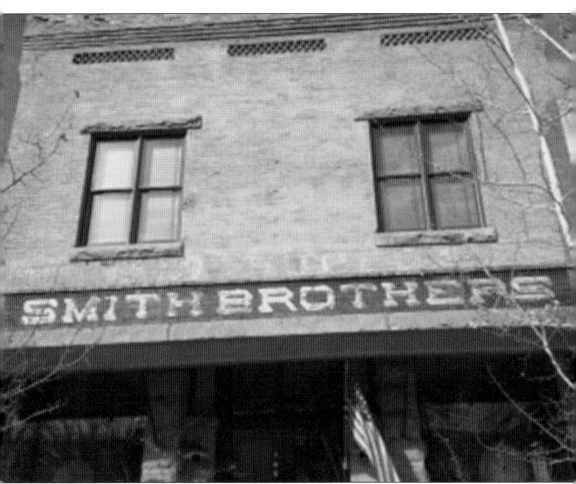

The Smith Brothers Building, located across from the Sloss Building on Homestead Drive, once housed the IOFF (Independent Order of Odd Fellows), a global altruistic and benevolent fraternal organization derived from the British Oddfellows service organizations of the 17th century. There are a number of explanations of the origin of the name. One of those comes from England in the 1600s, where it was odd to find people organized for the purpose of giving aid to those in need and pursuing projects for the benefit of all mankind. Those who belonged to such an organization were called Odd Fellows. The building was also the site of Albert Danielson's funeral in January 1917. Today, a faded plaque, with a photograph of the lodge members at the funeral, stands in front of the building, commemorating its historic place in Basalt history.

ALL AMERICA LOVES COLORADO PEACHES

While the Denver & Rio Grande Western endlessly promoted Colorado, its cities, towns, and products, another great contributor to the economy of the state was the fabled Colorado Midland Railway. The Midland, during its brief existence, introduced thousands to the beauty of the state through the vehicle of such promotions as the Wildflower Excursions, which operated from Glenwood Springs and allowed passengers an opportunity to enjoy the fields and meadows in many parts of a then much different Colorado. Because of the current lack of rail service to the upper valley, most of today's citizens don't have a true appreciation for the historic link between Basalt (and its environs) and the railroads which once served it. (Both photographs courtesy of Seth H. Bramson and the Bramson Collection.)

Wild Flower Excursion from Colorado Springs, Colo. On line of the Colorado Midland Railroad.

Denver
and
Rio Grande
Western
Railroad

Time Tables

AVOID WASTE
KEEP THIS TIME TABLE

This is the cover of a Denver & Rio Grande Western July 1922 passenger timetable, which included service on the Aspen Branch from Glenwood to Carbondale, Emma and Aspen. What is of particular interest here is that the passenger service on the D&RGW did not stop in downtown Basalt, but rather at its depot to the south in Emma. In some areas near the current Emma Store, house and school, portions of the tracks and rail bed are still extant along the bike trail, which replaced most of the rail line. (Photograph courtesy of Seth H. Bramson and the Bramson Collection.)

The D.& R.G. Depot, Glenwood Springs, Colo.

The Glenwood Springs D&RGW depot is seen above in the early years of the 20th century. The station was later rebuilt and moved to the east (its present location). The old Aspen station, no longer in active use, is shown in the 1954 photograph below. The California Zephyr still serves Glenwood from Denver and points east, to the West Coast. The old Aspen line came through parts of what are today Woody Creek, north of the current airport and then over the Maroon and Castle Creek bridges to the final stop on the Aspen branch, just north of the current downtown. (Both photographs courtesy of Seth H. Bramson and the Bramson Collection.)

D&RGW DEPOT 1954
ASPEN, COLORADO

COLORADO MIDLAND RAILWAY.

Midland Route

TIME TABLES

SPECIAL EXCURSION
TO
Glenwood Springs

AND RETURN

SEPTEMBER 9

G. A. R. ENCAMPMENT
DENVER, SEPT. 4-7

AUGUST 1905

The Colorado Midland Railway is today held at a level of legend accorded to only a very few American railroad and electric railway lines, among them the Pacific Electric; New York, Ontario & Western; and the Florida East Coast Railway's Key West Extension. Any collectibles from the Midland are considered to be, in terms of value, at the highest level in the railroadiana (historical railroad memorabilia) collecting field. This August 1905 passenger timetable, from the collection of Seth H. Bramson, with its GAR (Grand Army of the Republic) excursion featured on the cover, is a fine example of highly sought-after Midland material. (Photograph courtesy of Seth H. Bramson and the Bramson Collection.)

Colorado Midland trains served Aspen, El Jebel, Carbondale, and Glenwood as well as other cities and towns via Basalt, which at that time was an important junction point on the railway, with two trains daily in each direction on the Aspen Branch line. Both passenger and freight trains plied the tracks through the hub of downtown Basalt. (Photograph courtesy of Seth H. Bramson and the Bramson Collection.)

The Reverend William Law was Pastor of the Basalt Methodist Church from 1890–1900, before the town was officially incorporated, but the town name had already taken on common usage. (Photograph courtesy of Lois Arbaney and the Arbaney Family Collection.)

After the demise of the railroads, some of the rails were removed in 1921 by the Colorado Midland Railway. In this photograph from 1977, Laurent Arbaney Sr. assists in the placement of rails from the Arbaney Spur in front of Bank of Basalt. Those rails are there today. (Photograph courtesy of Lois Arbaney and the Arbaney Family Collection.)

The year is 1962, and this late 1950s model sits on Homestead Drive, the streets still unpaved. (Photograph courtesy of Lois Arbaney and the Arbaney Family Collection.)

Still together and working hard after all these years, the men of the Arbaney and Gerbaz families take a break at the ranch in this photograph from the 1970s. (Photograph courtesy of Lois Arbaney and the Arbaney Family Collection.)

The back of this 1973 postcard read, "Hi! Merry Christmas from the Childs." It was sent from Bob Child, longtime Pitkin County commissioner, to Laurent and Irena Arbaney in 1973. The photograph was taken at the Child Ranch in Old Snowmass, and went 4.5 miles to Basalt. In 2012, Steve Child, Bob's son was elected to the same county commission.

An ad from the old *Basalt Journal* promoting Sloss' Grocery and General Merchandise (Mdse.) Store is shown here. On page 86 of this book, the photograph of the restored Sloss Building has an S added after the apostrophe. (Photograph courtesy of the Denver Public Library and Library of Congress Collections.)

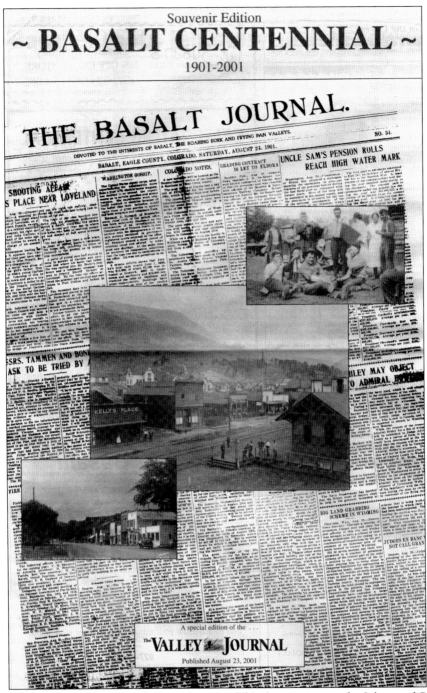

While copies of the original *Basalt Journal* are available for viewing on the Library of Congress and Denver Library virtual websites, this souvenir edition of the *Basalt Centennial*, from 2001, has many original stories and photographs celebrating the town's 100 years of success. In a story by Janice Duroux, of the Basalt Regional Heritage Society, who has graciously provided many of the resources for this book, she details the family names which made such a profound impact on the growth and development of the Basalt area.

In this incredible shot from the Cardiff stop on the Colorado Midland line, Ollie Lea Moore (standing second from left) and his fellow workers gather by C.M. Steam Shovel No. 3 with freight car 3002 in the background. Moore is apparently no relation to Joe Moore, of Brass Whistle in Glenwood, who has provided several wonderful images for the book. (Photograph courtesy of Joe Moore and the Brass Whistle.)

This is a beautiful later view of six of the kilns, or coke ovens, taken after they had already been fenced to protect them from destruction and further decay.

Today's Basalt Town Hall, featured in this winter view, stands in Lions Park near the northeast corner, which the railroad yards once occupied. It is directly across from the historic Snell Building (see page 54). The former train yards now host concerts and events and serve as the home of the Basalt Chamber of Commerce Caboose and the Wyly Community Art Center.

The attractive Riverside Plaza stands at Basalt's highest traffic and pedestrian intersection, the corner of Midland Avenue and Two Rivers Road, which was formerly the old highway into town. Another interesting feature of the Riverside property, which includes residential and commercial uses, is that some of the condo residences sit right at the confluence of the two rivers, the Frying Pan and the Roaring Fork.

Seven

INTO THE FUTURE,
EMBRACING THE PAST

The redevelopment of a mixed-use property in the heart of downtown Basalt will include a collaboration by the town of Basalt, the renowned Rocky Mountain Institute (RMI), Colorado Mountain College (CMC), plus office/retail units, a new boutique hotel, the relocated home of the nonprofit Roaring Fork Conservancy, and employee and free-market housing.

This will prove to be an enormous boon to the Basalt downtown core. With the 2012 opening of the new Whole Foods Market in the Willits area, the development of Willits Town Center, El Jebel Center, Orchard Plaza, the planned Tree Farm development, and Shadowrock Townhomes, the west portion of Basalt is seeing a renaissance, as well. Real estate sales and rentals are trending upward and new businesses are now calling both downtown Basalt and Willits their home.

Basalt has grown with some of valley's finest restaurants, galleries, local shopping, an extensive system of biking and hiking paths, river rafting, horseback riding, skiing and hot air ballooning within 20 minutes in each direction, and a population which is once again protective of its heritage. The aforementioned qualities and location on the rivers, provide Basalt with some very unique ingredients, which are now beginning to come to light once again, and attracting a new legion of faithful to its environs.

In 2011–2013, these new initiatives led to a positive turn in Basalt sales tax revenues for the first time in several years. The financial, real estate, and business trends are positioning Basalt as the place to be in the Roaring Fork Valley and for locals, visitors, and guests, the new Basalt history is all about becoming the "Confluence of Rivers, Recreation and Culture."

Here is the new Basalt, where you can meet the names, faces, places, people, and stories which have led to the birth and growth of this gem of a Colorado town, served as the foundation for its rebirth in the 21st century, and are leading it toward a solid and bright future.

This weathered photograph of early Basalt from 1904 is a view to the southeast, looking up valley. With the growing town in the foreground, the coke ovens are to the left, and the expansive Arbaney Ranch above them and to the right. To the right of the buildings is today's Lions Park and the Midland cut-off, which is the site of the present day Pan and Fork Mobile Home park, now owned by the Roaring Fork Development Corporation. It is slated to be the site of a mixed-use development housing, the Rocky Mountain Institute, a campus of Colorado Mountain College, and a new, much needed, boutique hotel.

The "new" Basalt post office was built in February and dedicated in June 1963. Mrs. Anna Paddock, postal mistress of Basalt for 25 years before Maude Elmont, was a guest speaker. An explosion raised the roof in 1974, and postal service moved to the Legion Building on Homestead Drive from 1974–1977, before relocating to the Darien/Block building in June 1977. A new post office was opened in the 1990s near the Midland Avenue entrance to town. This site today is a parking lot next to the Conoco Phillips gas station downtown. (Photograph courtesy of Lois Arbaney and the Arbaney Family Collection.)

This 1986 view of the Alpine Bank, formerly Bank of Basalt, which has gone through several changes, still remains an iconic image at the center of today's downtown Basalt. Photographs of the same structure can be seen throughout the book, including the final photograph on page 126. (Photograph courtesy of Lois Arbaney and the Arbaney Family Collection.)

Today, Basalt High homecoming has once again become a celebrated community event, thanks to the efforts of Beth Mobilian and an active group of school Boosters. Here is a view of the 1961 parade passing the Basalt Café and Sundry. Notice all the liquor ads. (Photograph courtesy of Lois Arbaney and the Arbaney Family Collection.)

The Basalt High marching band was a popular addition to any community event or parade. Since 1951, Aspen's Winterskol event has been a celebration of winter and here the BHS marching band joins the annual parade in 1959. Today, the parade has been replaced by an all-day festival. The author has served on the Aspen Winterskol committee from 2002–present. (Photograph courtesy of Lois Arbaney and the Arbaney Family Collection.)

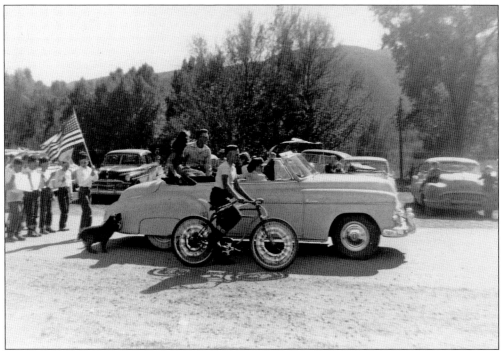

Homecoming is always a special occasion. Lining up for the October 1954 parade are Homecoming King Jerry Gerbaz and Queen Janet McCune. They are accompanied by their security detail on bicycle and a dog at the rear of the car, and followed by a group of students carrying the American flag. (Photograph courtesy of Lois Arbaney and the Arbaney Family Collection.)

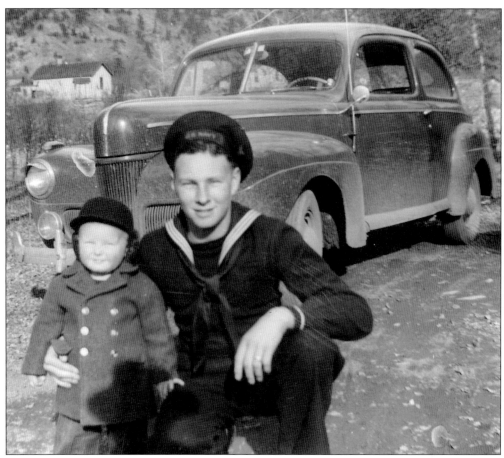

Little Kelvin Arbaney (left) with yeoman Desmond Harris before Desmond's departure for overseas naval service in 1942. Today, Kelvin lives in Battlement Mesa, further down valley, with his lovely wife, Lois, who has graciously made many of the family photographs available for this edition. (Photograph courtesy of Lois Arbaney and the Arbaney Family Collection.)

The new Basalt library, dedicated in 2010, is located at the town entrance, off Basalt Avenue. The previous iteration of the library branch was located in a 1950s building, next to town hall, in Lions Park. It is now being leased by the town of Basalt to Wyly Community Arts Center, a wonderful local nonprofit, which provides art classes, lectures, and artist exhibitions. (Photograph courtesy from the author's personal collection.)

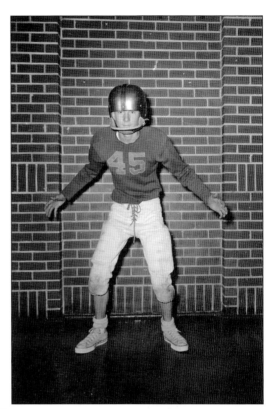

It is the late 1950s, and little Kelvin Arbaney has grown up. Here are his Basalt High School football and basketball photographs. Hook 'em Horns! (Both photographs courtesy of Lois Arbaney and the Arbaney Family Collection.)

The Basalt Union High School was erected in 1938. The new elementary school, shown above, and middle schools are on the same campus as the former high school. For some years, the old high school sat unused, and for a three-year period in the mid-2000s a group of active citizens created the nonprofit Founding Board of the Basalt Old Brick School (on which the author served), in an effort to restore the building and create community nonprofit offices, a renovated community-use room, and gymnasium. But after substantial funds were raised, the project was shelved when the area population grew and the Roaring Fork School Board determined that the building was needed for overflow classrooms. A new high school was built in the South Side area of Basalt across Highway 82. (Photograph from the author's personal collection.)

Shown here is the dedication plaque for Basalt Union High School (1938), which served students of many ages (the Elementary was at the same site). A view of the plaque reveals some very familiar names, including Hyrup, Grange, Cerise, and Favre. Today, the new Middle School and Elementary Schools share the site, and the new Basalt High School is across Highway 82, in the area of South Side and the Basalt Business Center. (Photograph from the author's personal collection.)

BASALT SCHOOLS

The first school in Aspen Junction was a small, white one-room frame structure for all grades. The school was on Third Street (now Hillside Drive) and was occupied for ten years until the late 1890's. Anywhere there were enough children to hire a teacher there was a one-room school house. There were school houses in Emma, El Jebel, Missouri Heights, Snowmass, Capitol Creek and Brush Creek.

On the Eagle-Pitkin County line the Basalt Public School began as a one-room brick building with no plumbing. The schoolhouse expanded in 1902 to a four-room, two-story brick building with a small bell tower on the roof. This building housed first through tenth grades and was administered by four teachers, and was heated with potbellied stoves with outhouses providing for nature calls. The school was surrounded by farm fields and students could walk or ride a horse to school with a horse shelter built behind the school. The bell was removed from the tower in 1914 because of structural instability.

In 1938 the old structure was torn down and replaced by Basalt Union High School. Basalt Union High School was built with funds from the Federal Emergency Administration of Public Works. The building accommodated all students with three grade school classrooms, three high school classrooms, a library, gymnasium and stage at a cost of $44,454.00. Additional property was purchased from Emery Arbaney for playgrounds. The original 48 year old building was completely renovated for $610,000.00 in the summer of 1985.

The original bell stands before you on the concrete pedestal. It was rededicated in June 1, 1986. Additional farmland was purchased from the Fredrick and Josephine Arbaney family to build the current additional school buildings and playing areas.

Basalt Regional Heritage Society Walking Tour Est 2003

The Basalt Regional Heritage Society, so named because the Basalt environs cover a more expansive area than just downtown, has placed placards at many of the historical sites, such as this one on the grounds of the Basalt Union High School. Unfortunately, many of the plaques have become aged, wear-worn, faded, or scratched, and an effort is being made to replace them with newer, more attractive versions. (Photograph from the author's personal collection.)

Old farm equipment still lies rusted on the site of the former Arbaney Ranch, maybe where it made its last pass on the fields before its final resting place. (Photograph from the author's personal collection.)

Imagine what tales this old rusted car from the early part of the century could tell of its active days tooling around the area. (Photograph from the author's personal collection.)

The former Luchsinger home in what was once the site of the original Frying Pan settlement, which later moved to the current downtown location, is shown here. The two sites are about 400 yards apart, but required crossing the Frying Pan River to the area of the rail depot, which may have made for a very tedious experience. (Photograph from the author's personal collection.)

This Sundance Books card photograph by Russ Collman shows the second depot in the 1940s and 1950s in its role as a Standard Oil station and garage. The west side of the building has been renovated to create an area for cars to enter. While cars wait for servicing (in those days, these were true "service" stations), a boy waits on his bike in front, and a large truck tire sits on the side.

Passenger service to Basalt had ended, but freight continued to ply the rails. This April 16, 1918, Colorado Midland timesheet from Cardiff to Leadville and Leadville to White Horse had all the pertinent information to get the engineer (No. 7) paid. He was driving Engine No. 1 and train ax. It was scheduled to depart at 9:15 a.m. but did not leave until 11:05. The names of the fireman and conductor, Manis and Lee, are noted as well.

Do You Know What

"Hits the Bull's-eye of the Rockies?"

Of Course You Do

there's only one

answer

MIDLAND ROUTE

No. 6 Leaves Basalt at 8:05 p.m.; Arrives Denver 8 a.m

SPLENDID SERVICE TO ALL STATE POINTS

OBSERVATION CARS

DINING CARS ON ALL TRAINS.

Inquire About Our Winter Tour Rates to Pacific Coast Points. Any Agent or

C. H. SPEERS, Gen. Pass. Agent, DENVER

This advertisement from the *Basalt Journal* touts the Colorado Midland's trip to Denver and "splendid service to all state points." The 270-mile trip only took 12 hours one-way. (Photograph courtesy of the Denver Public Library and Library of Congress Collections.)

Many of the area schools were small, single one-room frame buildings. This photograph of the Catherine School, a bit further down valley, helps us understand that it was a simpler time, when many of the students of all grades were taught in a single location with one teacher. (Photograph courtesy of Lois Arbaney and the Arbaney Family Collection.)

This iconic photograph shows, in great detail, the last passenger train out of Basalt, heading east, as it chugs out of town, into history. The smoke from its stack creates an eerie, twilight haze. Freight cars sit silently on sidings, including one on the left in front of the Snell Building, on what is today called the Midland Spur, connecting to Two Rivers Road. (Photograph courtesy of Lois Arbaney and the Arbaney Family Collection.)

The original Methodist Church on Homestead, once Hillside, has been remodeled, with more modern additions. At the time of writing, the now mixed-use commercial residential property is on the market for sale. (Photograph from the author's personal collection.)

Kelly's Trout Lake, Basalt, Colo.

An amazing view of Kelly's Trout Lake, with two fishermen paddling around as a herd of cattle makes their way down to the water's edge, is shown here. (Photograph courtesy of Joe Moore and the Brass Whistle.)

This postcard from Basalt is most likely either Kelly's Trout Lake or the current Tree Farm Lake, near El Jebel. Because of the lack of mountains, we have to assume that this is not from the Ruedi Reservoir. (Photograph courtesy of Joe Moore and the Brass Whistle.)

Greetings from BASALT, COLO.

Fifteen members of the Leap Year Club of Basalt pose in two lines, their names now obscured from history. Their clothing, characteristic of the early 1900s, includes long-sleeved, high-collared blouses with puffy sleeves and long skirts. Several wear attractive jewelry including earrings, cameo broaches, and pendants. They stand before a painting of an ornate room. Women's and men's organizations of the time were segregated by gender, and these social, fraternal organizations played a large role in society at the time.

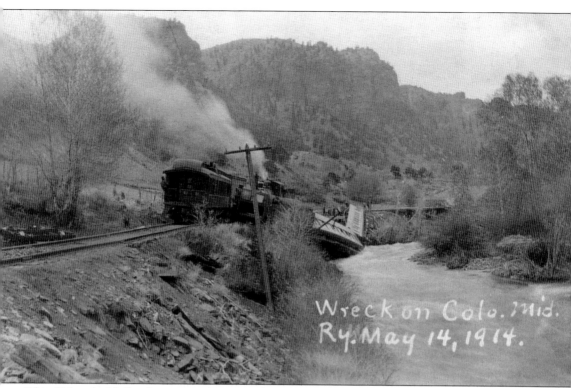

Wreck on Colo. Mid. Ry. May 14, 1914.

This Colorado Midland train wreck occurred on May 14, 1914, up the Frying Pan. The engine was towed back to town. Basalt was the site of other rail mishaps, as the photograph on the cover of this book demonstrates. (Photograph courtesy of Joe Moore and the Brass Whistle.)

While weathered and worn, this incredible view of the second depot is notable for many reasons. This is the current Alpine Bank building and the BASALT station sign is clearly visible under the lattice work. The second man from the right is station agent W.A. Melborne Jr. and his dog, Bruce, who was a familiar "hound around town." The two doors, labeled "Ladies" to the left and "Gents" to the right were not restrooms, but in fact, separate waiting rooms in the depot. Two women with hats, one looking toward the tracks and one looking away, can be seen in the far left window, while a baggage cart sits idle on the left side of the station awaiting the next passenger train.

BIBLIOGRAPHY

Danielson, Clarence L.; Danielson, Ralph W. *Basalt: Colorado Midland Town*. Boulder, CO: Pruett Publishing Co., 1971.

Denver Public Library Digital Collections.

Elmont, Earl V. *Basalt and the Frying Pan*. Basalt, CO: WHO Press, 2004.

Library of Congress, Digital Collections.

McNellis, Brian and Tomaskovic, Denise. *A Brief History of the Basalt Charcoal Kilns*. 2010.

DISCOVER THOUSANDS OF LOCAL HISTORY BOOKS
FEATURING MILLIONS OF VINTAGE IMAGES

Arcadia Publishing, the leading local history publisher in the United States, is committed to making history accessible and meaningful through publishing books that celebrate and preserve the heritage of America's people and places.

Find more books like this at
www.arcadiapublishing.com

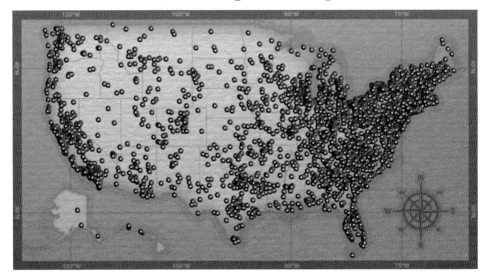

Search for your hometown history, your old stomping grounds, and even your favorite sports team.